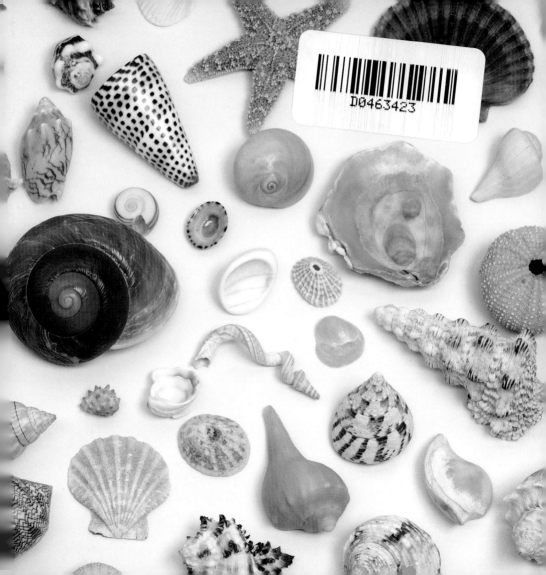

D0463423

A
Crazy
Little Series™

For my sisters Julie and Joan

Shell Crazy

by
Tracy Gallup

Mackinac Island Press

for the love of reading

Once I saw a painting

of a woman rising from some deep sea

standing on a boat-like shell

that floated toward shore.

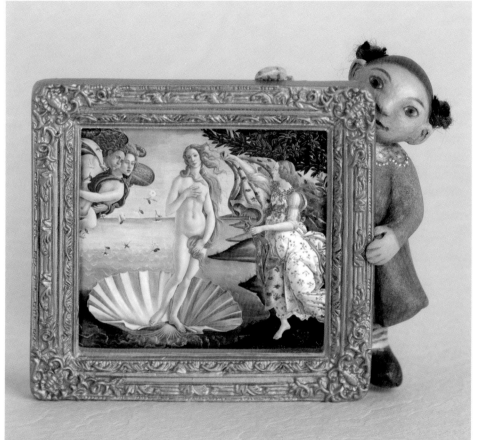

I dream I am her.

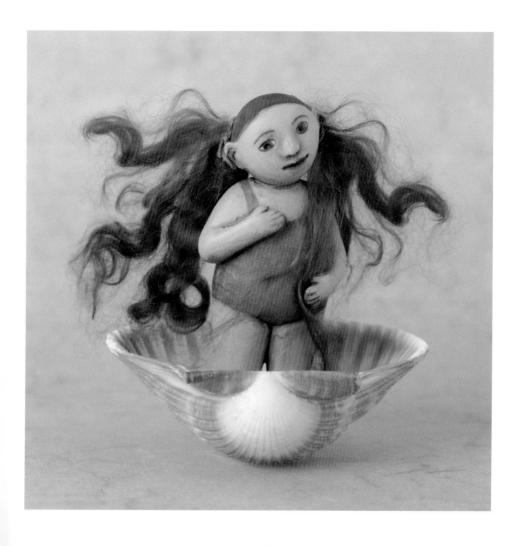

I like shells because they are houses.

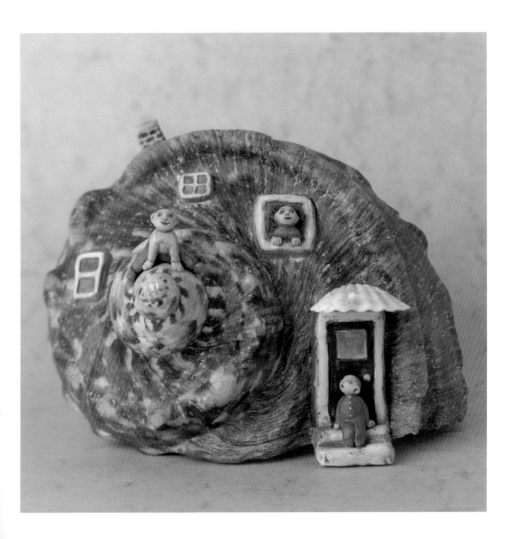

My brothers and I think

they make good hats,

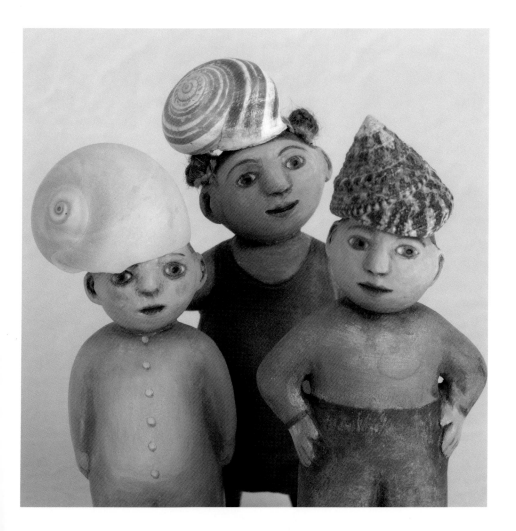

wings,

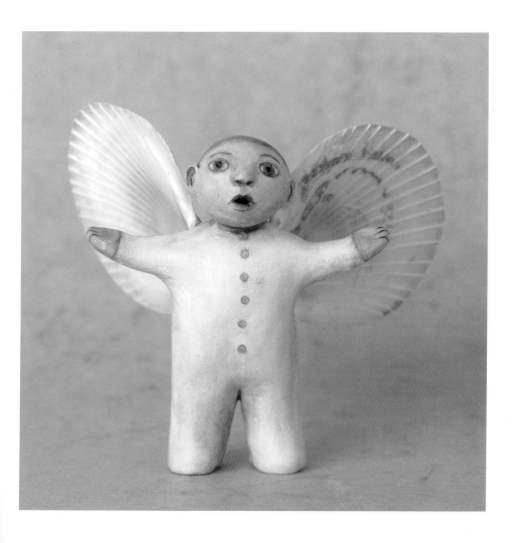

horns,

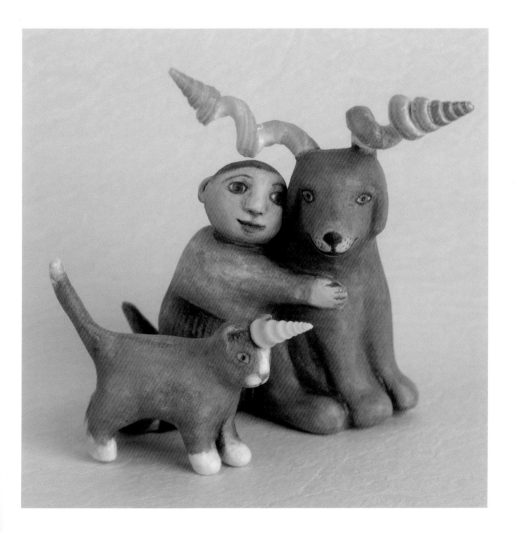

and boats.

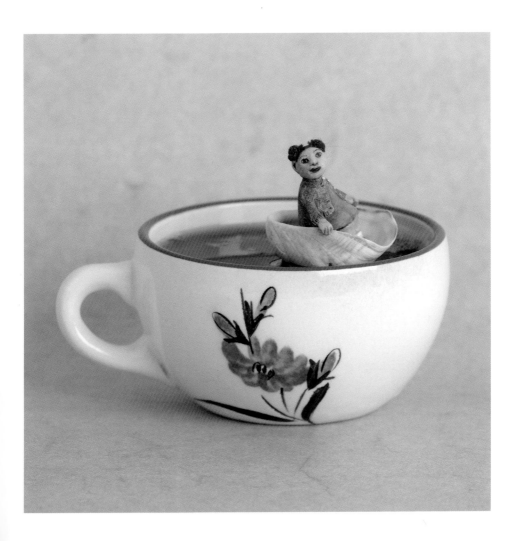

For our family vacation we go to the ocean.

At the beach the shells are so tempting

we cannot help but walk slowly,

stopping here and there to pick them up

like treasures.

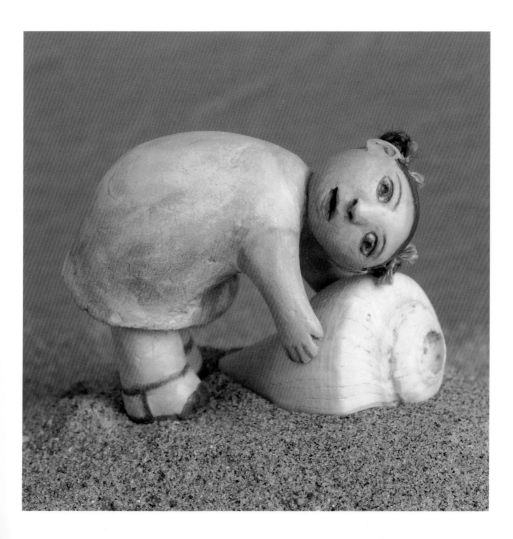

We call my brother Hawkeye

because he always spots the best shells,

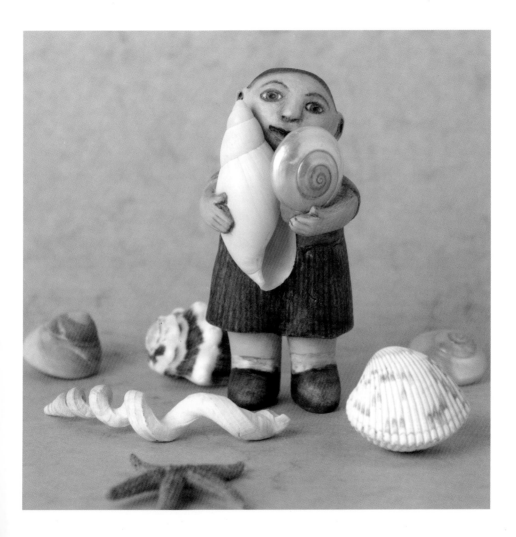

and the biggest.

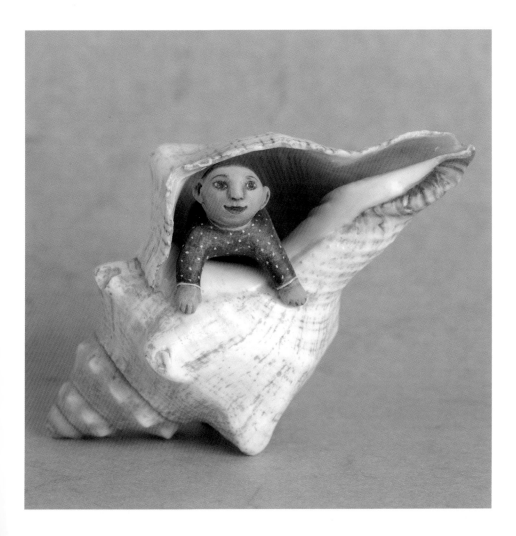

Mom collects shells

in the pockets of her summer dress,

and in the evening hands them out.

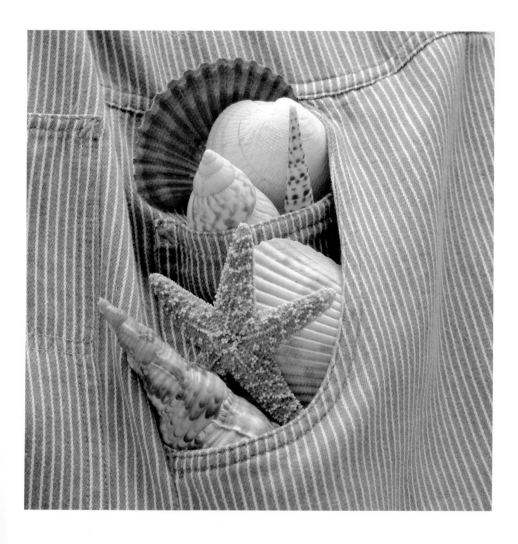

Like usual, Hawkeye gets the best one.

"But yours," Mom says,

"has something inside."

I don't see anything except a few grains of sand,

so I go back to the beach to watch the sunset.

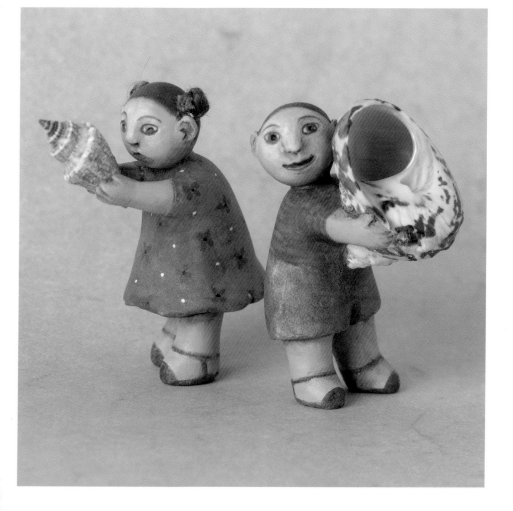

I stumble across a huge pile

of perfect shells almost covered by sand.

A few of them are familiar.

They couldn't be my brother's, could they?

No, he wouldn't leave these

beautiful shells behind…would he?

"Finders keepers," I whisper to myself

as I scoop them into my pail.

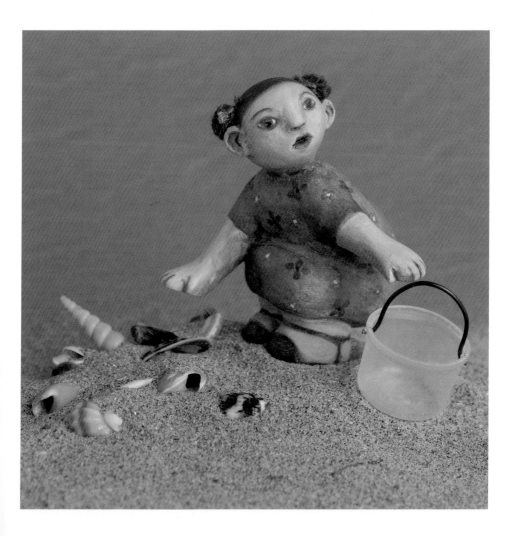

My brother cries when he finds out,

but I won't give them back.

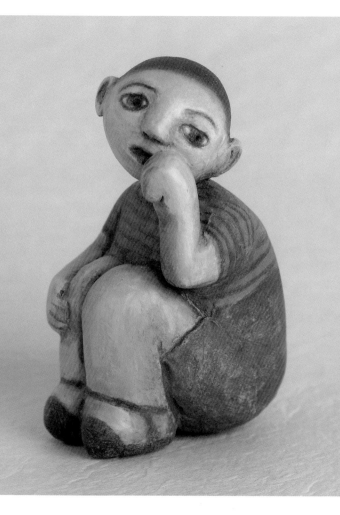

I hold my shell up to my ear

so that I don't hear him cry.

There is something inside,

just as my mother said.

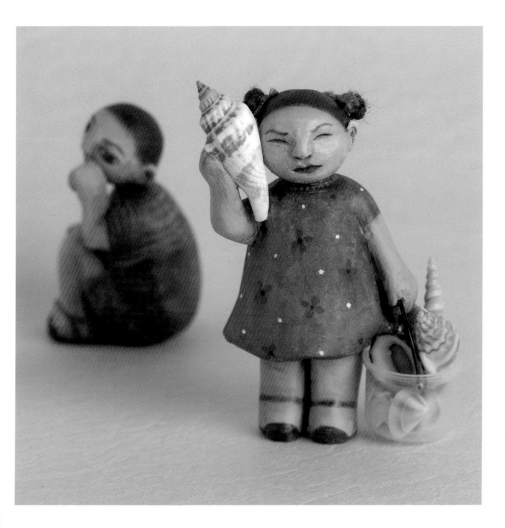

I hear the ocean

and waves splashing on the beach.

I feel warm sand on my feet.

I see myself floating

on rolling waves,

surrounded by so much blue!

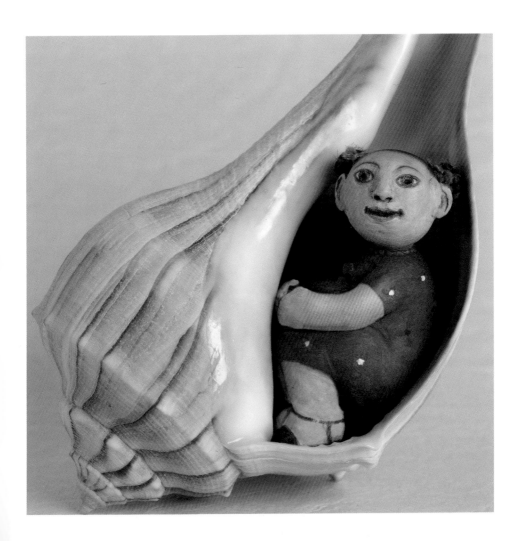

I return the shells to my brother.

Mine holds all that I need.

When a shell speaks to me,

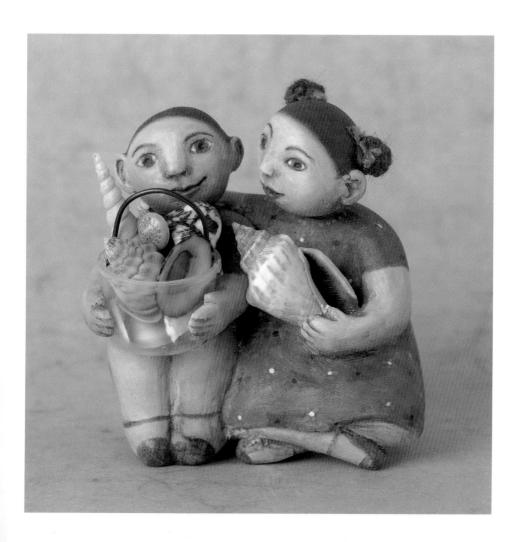

I listen.

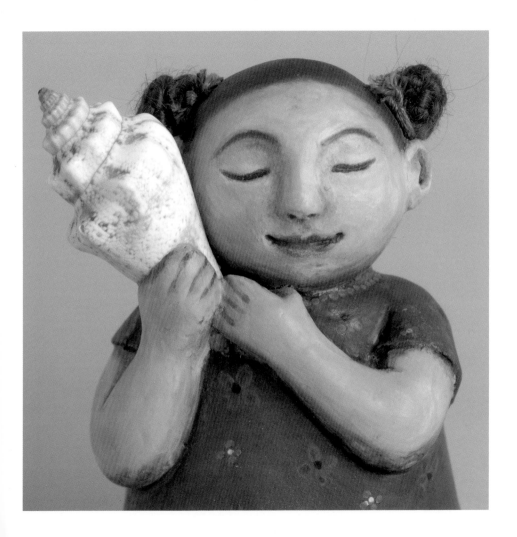

Library of Congress
Cataloging-in-Publication Data on file

Tracy Gallup
A Crazy Little Series™: *Shell Crazy*

ISBN 978-1-934133-14-9
Fiction

10 9 8 7 6 5 4 3 2 1

A Mackinac Island Press, Inc. publication
www.mackinacislandpress.com

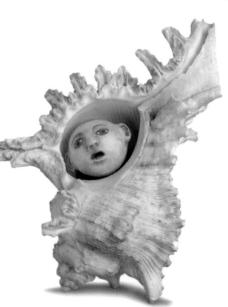

Printed in China

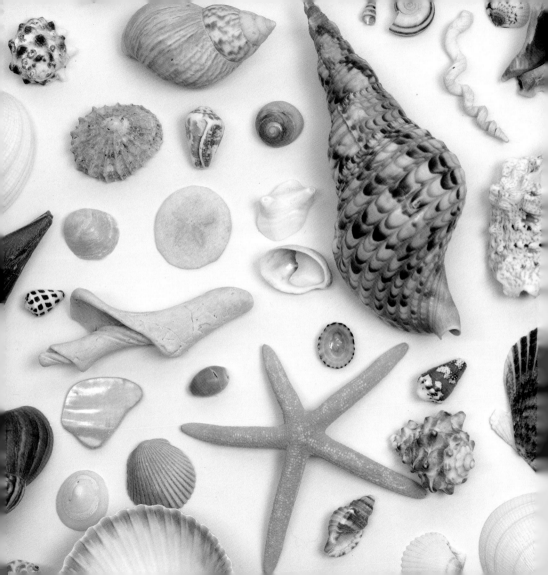